Connections

Unconscious connections in everyday photographs

ENIS MAHMUTOVIC

Copyright © 2016 Enis Mahmutovic

All rights reserved.

ISBN-13:
978-1532947674

ISBN-10:
1532947674

DEDICATION

To my beautiful wife and my wonderful children...

PAGES

1	Sky wheels	2
3	Dark look	4
5	A mystery	6
7	Social network	8
9	Water clouds	10
11	Dark lines in our life	12
13	Light lines in our life	14
15	Unknown and known	16
17	Ready	18
19	An individual	20
21	A northern day	22
23	Ethnic	24

…….

INTRO

You are looking at a short photo book that represents my view of photographs which were unconsciously made in connections to a photograph I took sometime before. I am not claiming that this a phenomena or somehow a hidden force behind my work, but simply an unintentional gesture, that I discovered later on.

Some images are obviously connected and some are left to be looked at and connected by the onlooker.

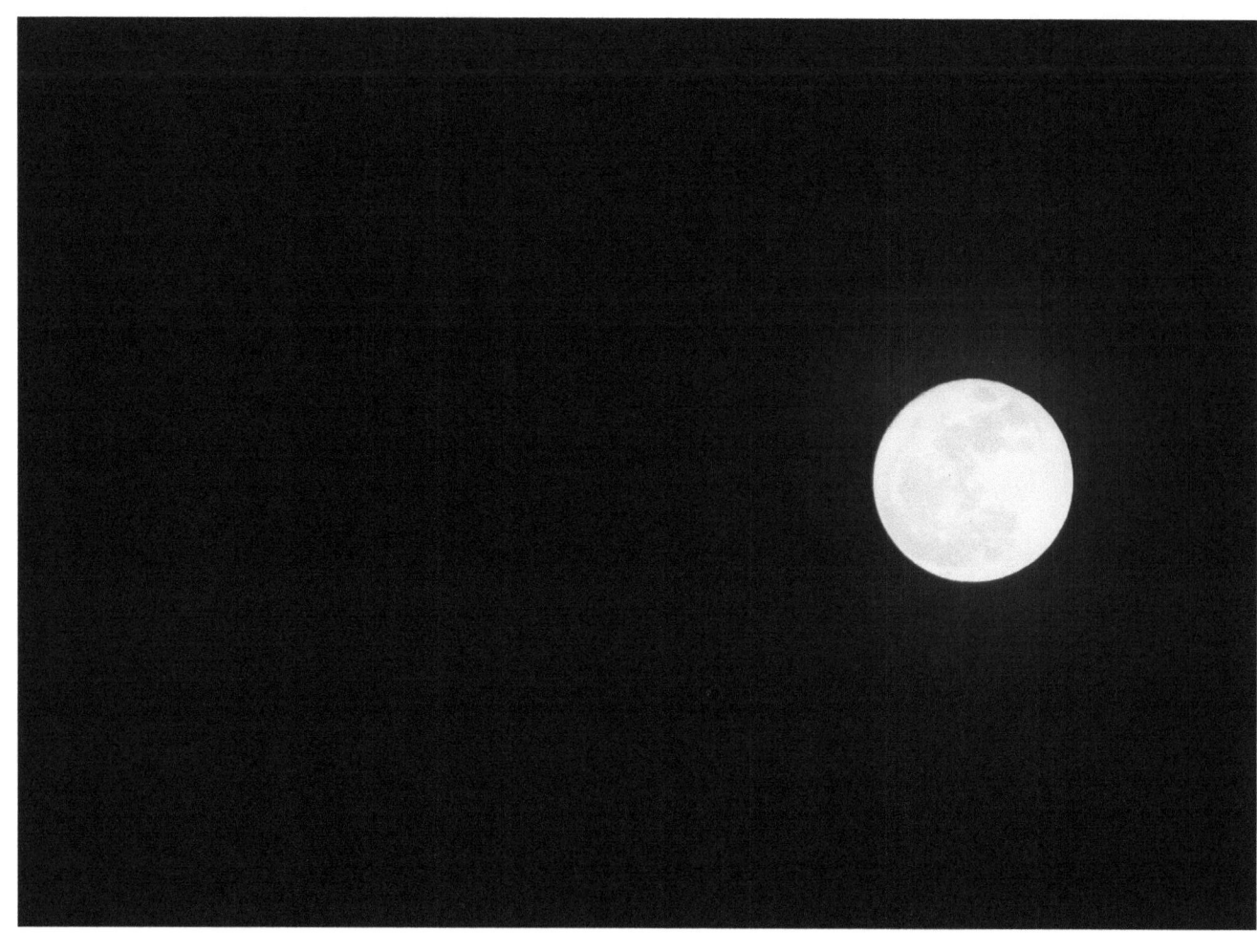

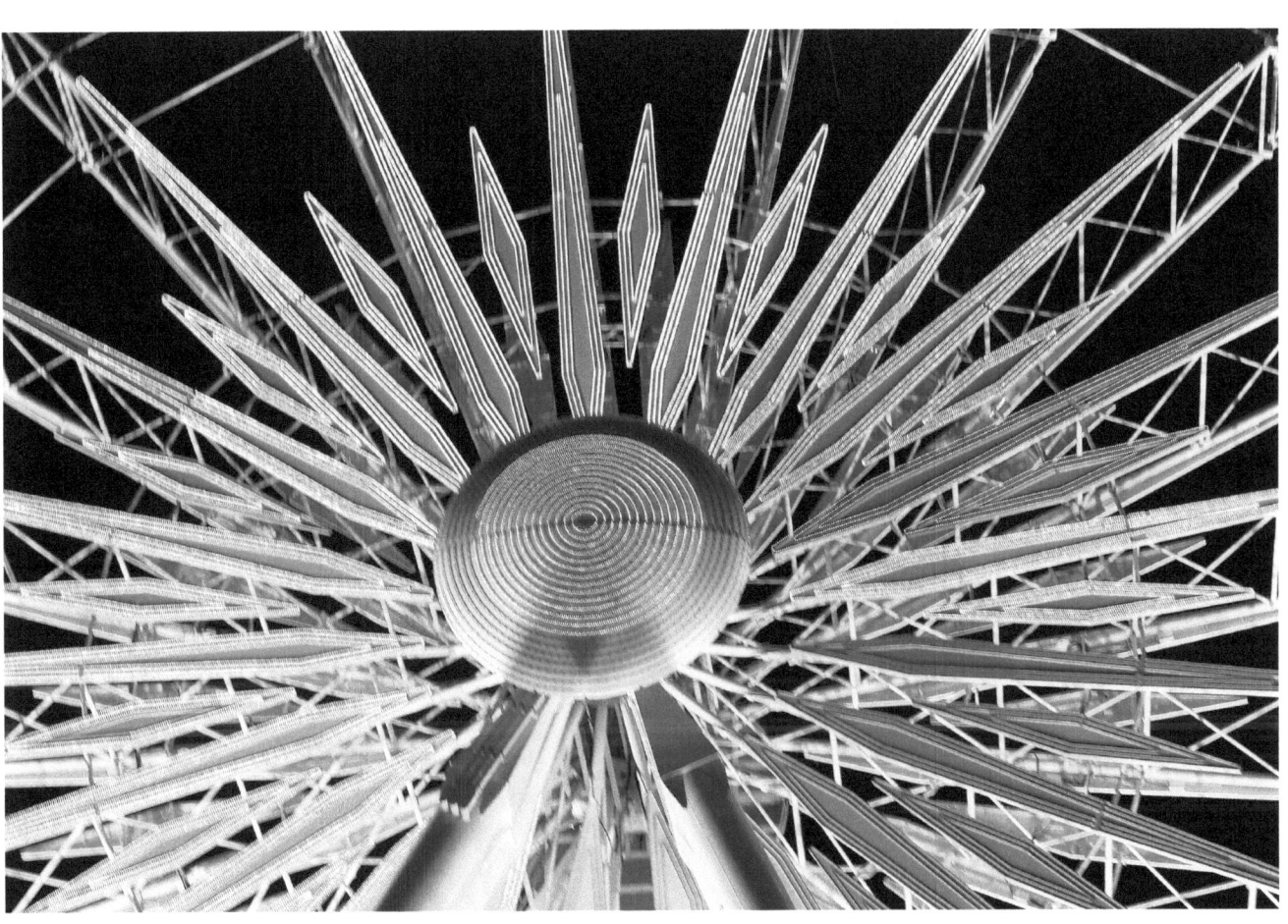

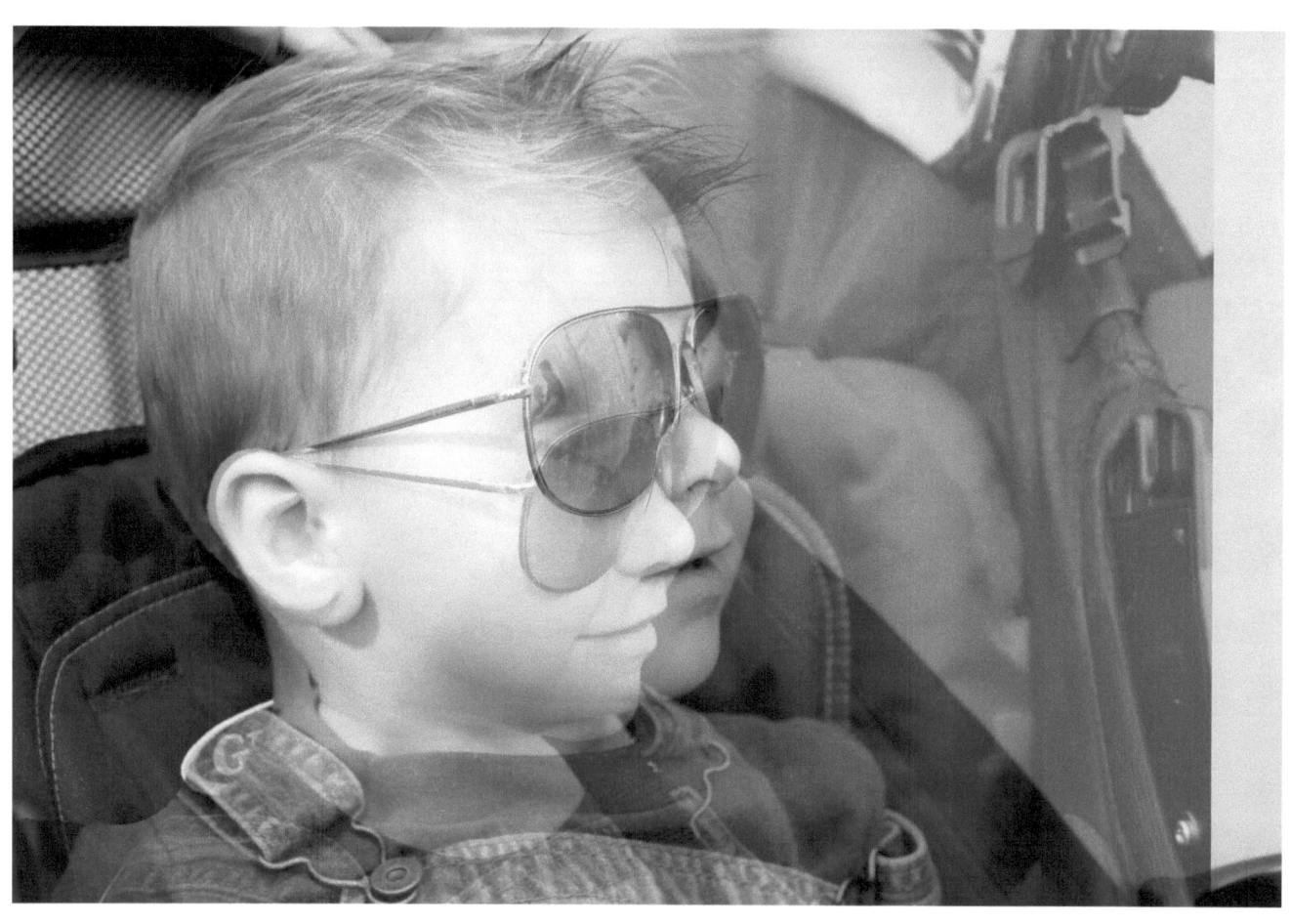

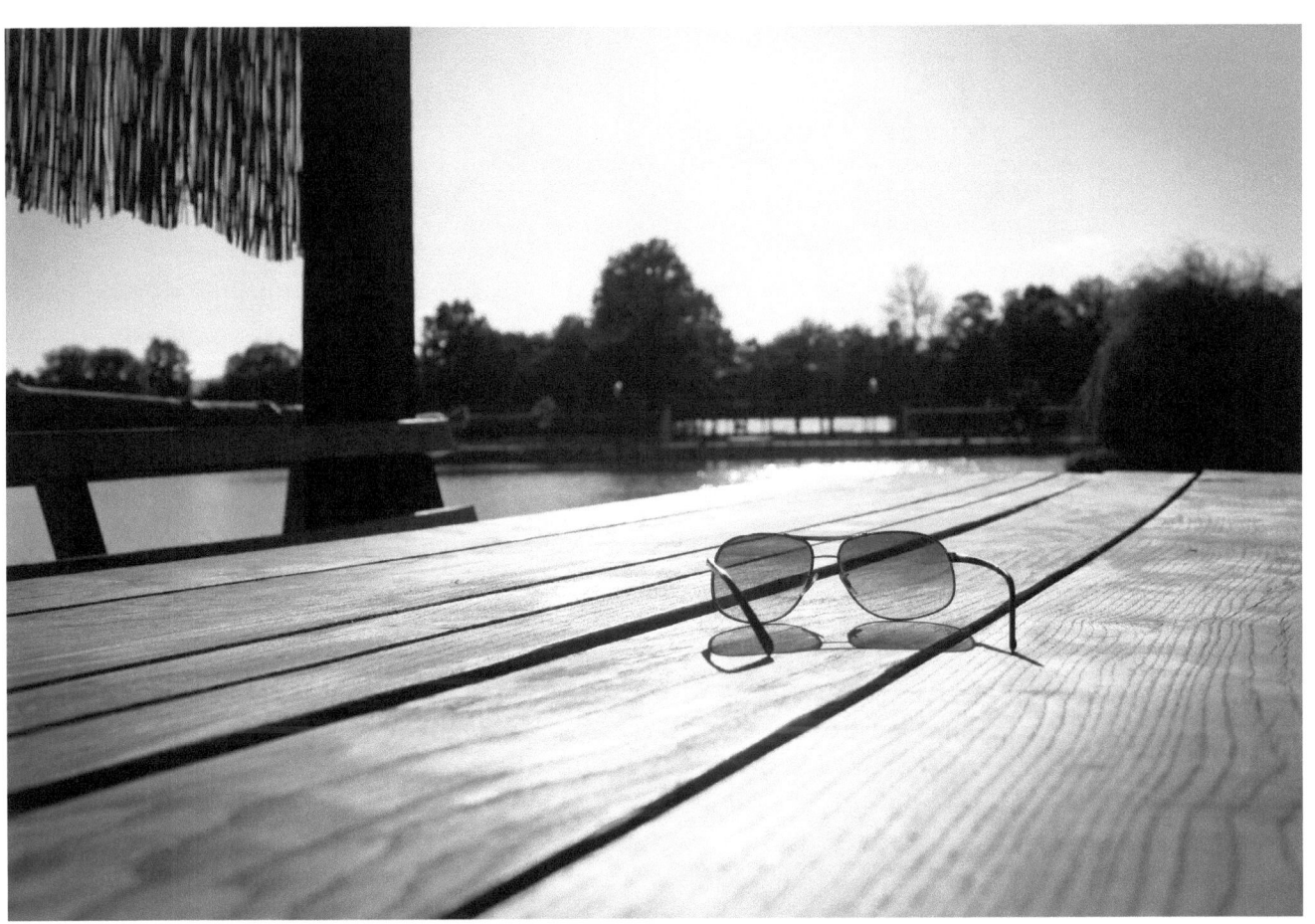

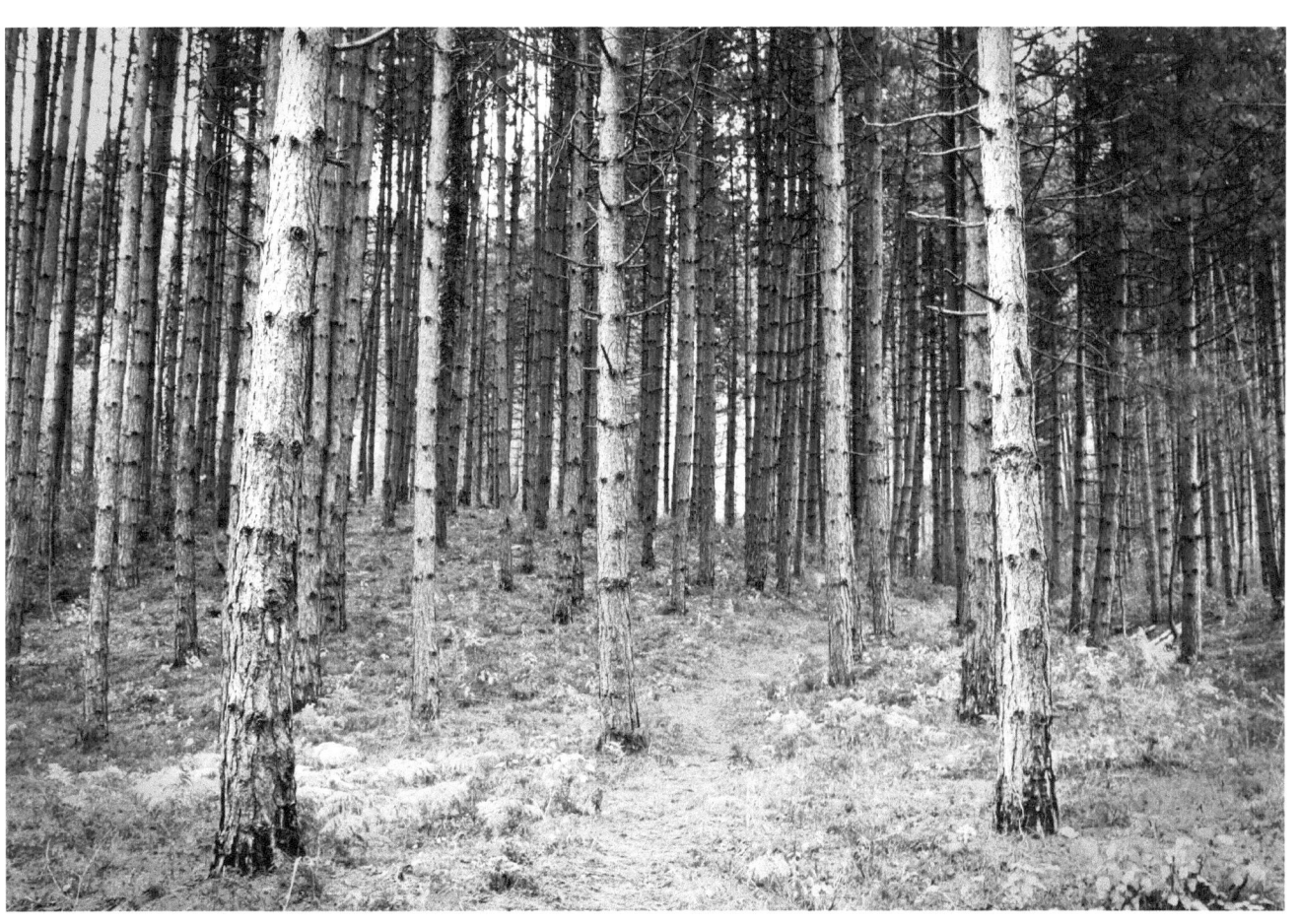

CONNECTIONS

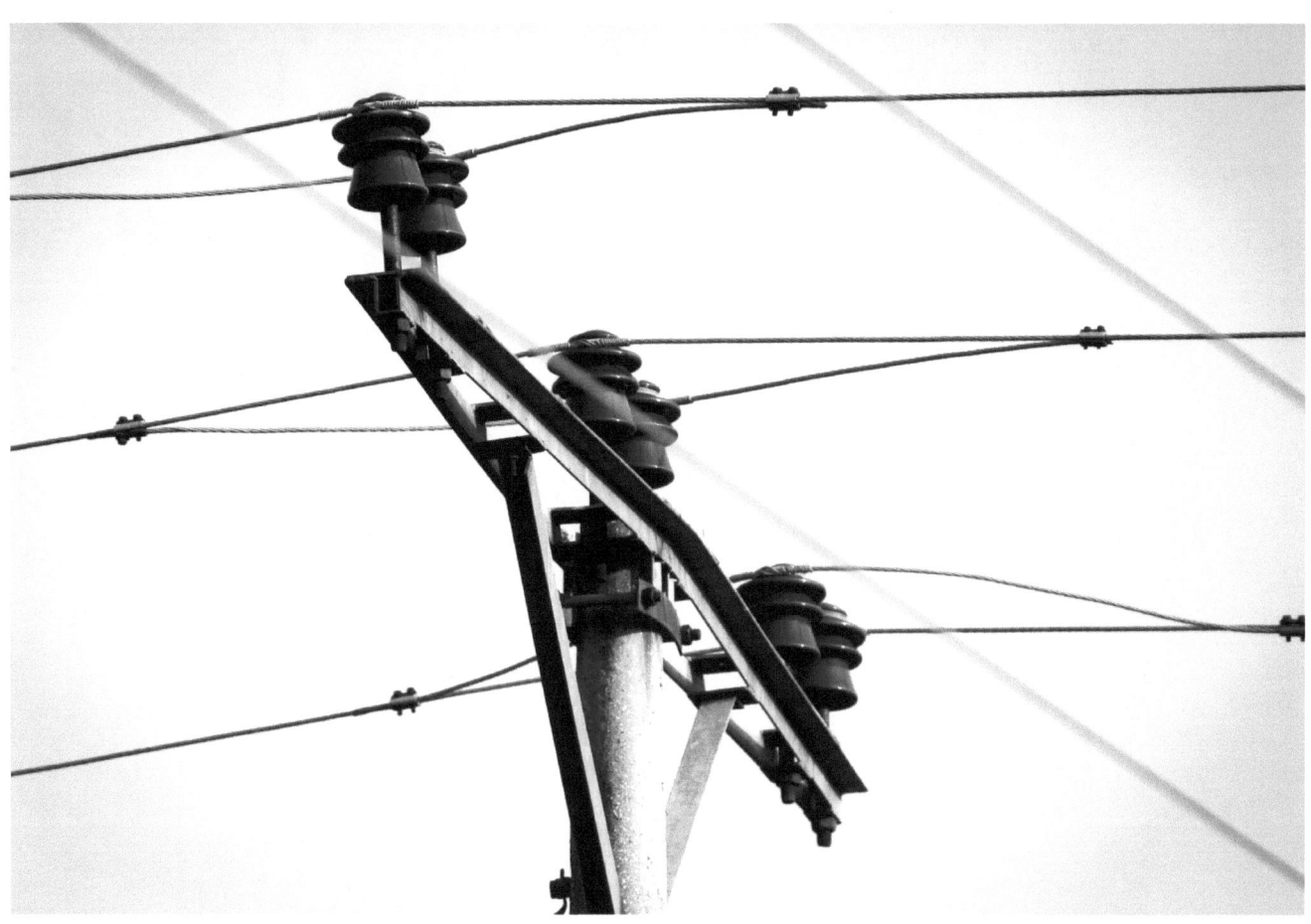

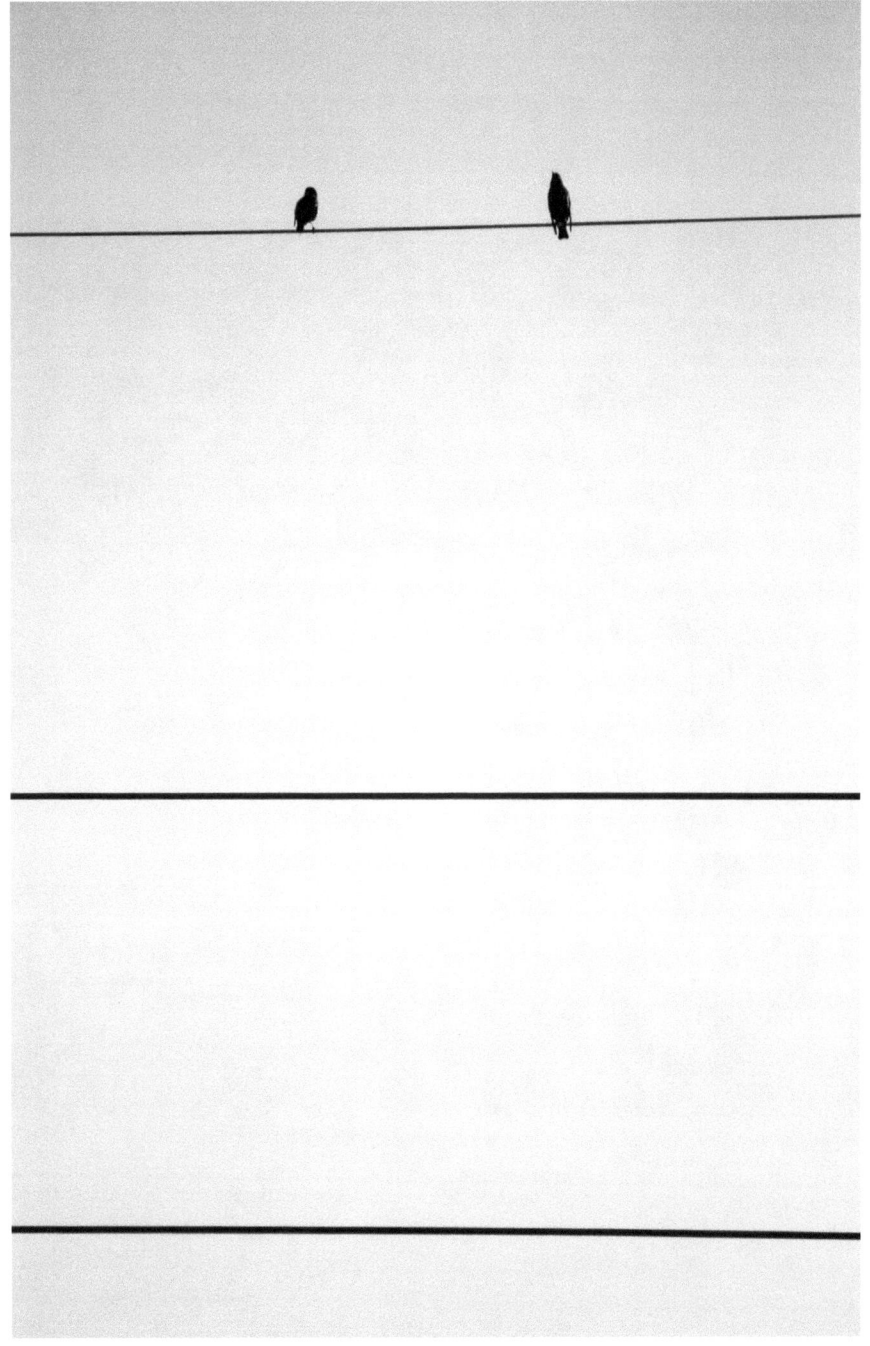

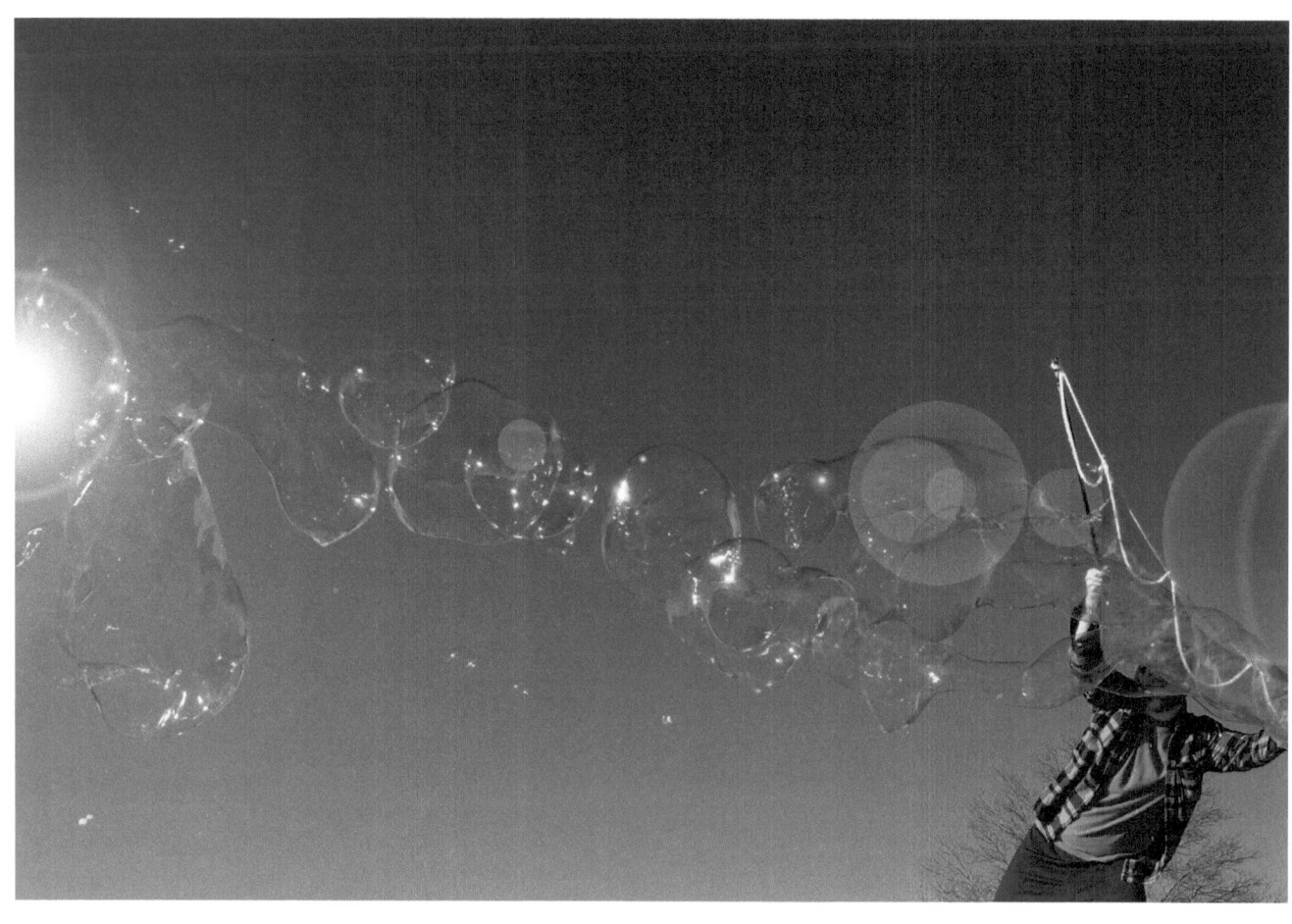

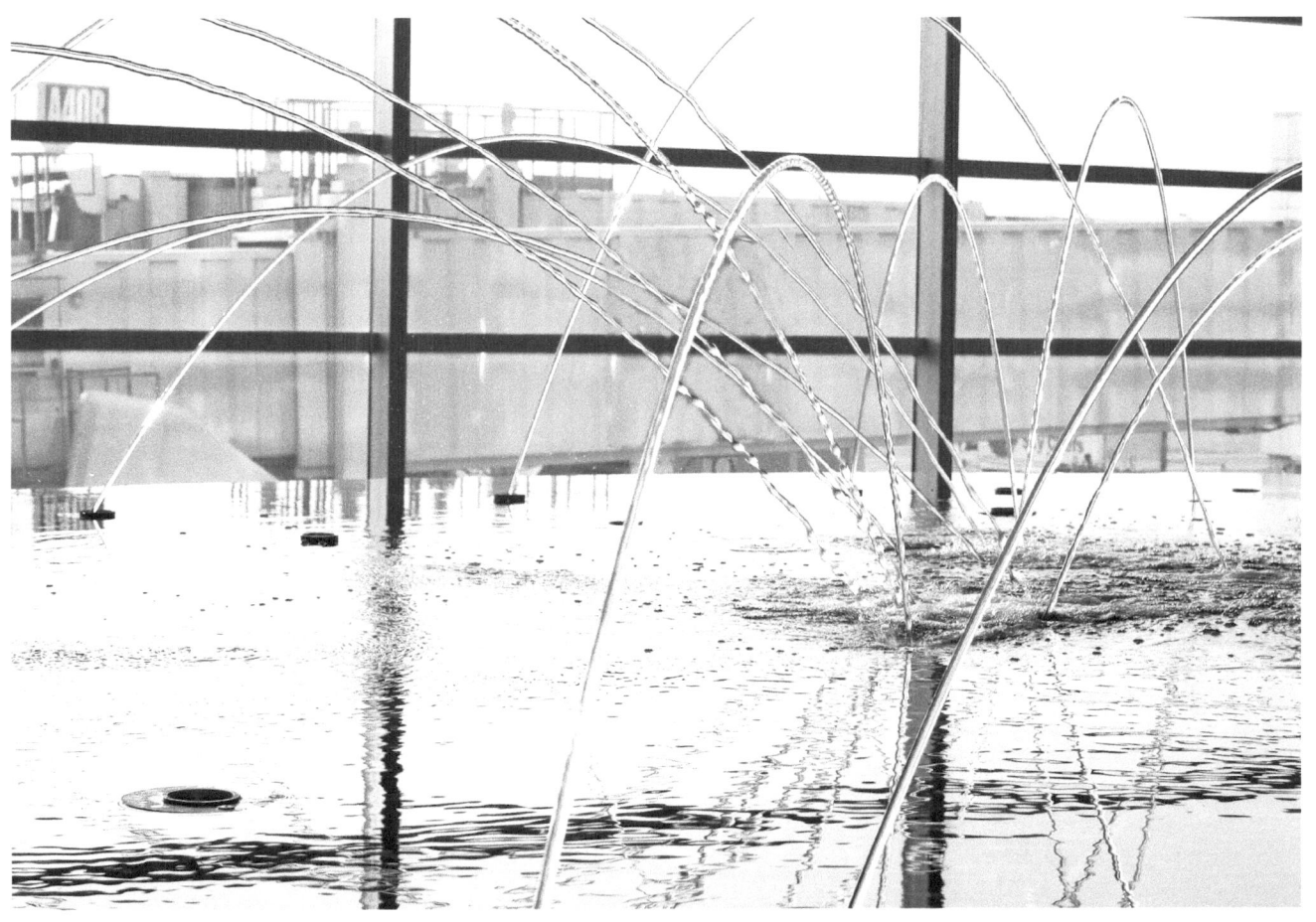

CONNECTIONS

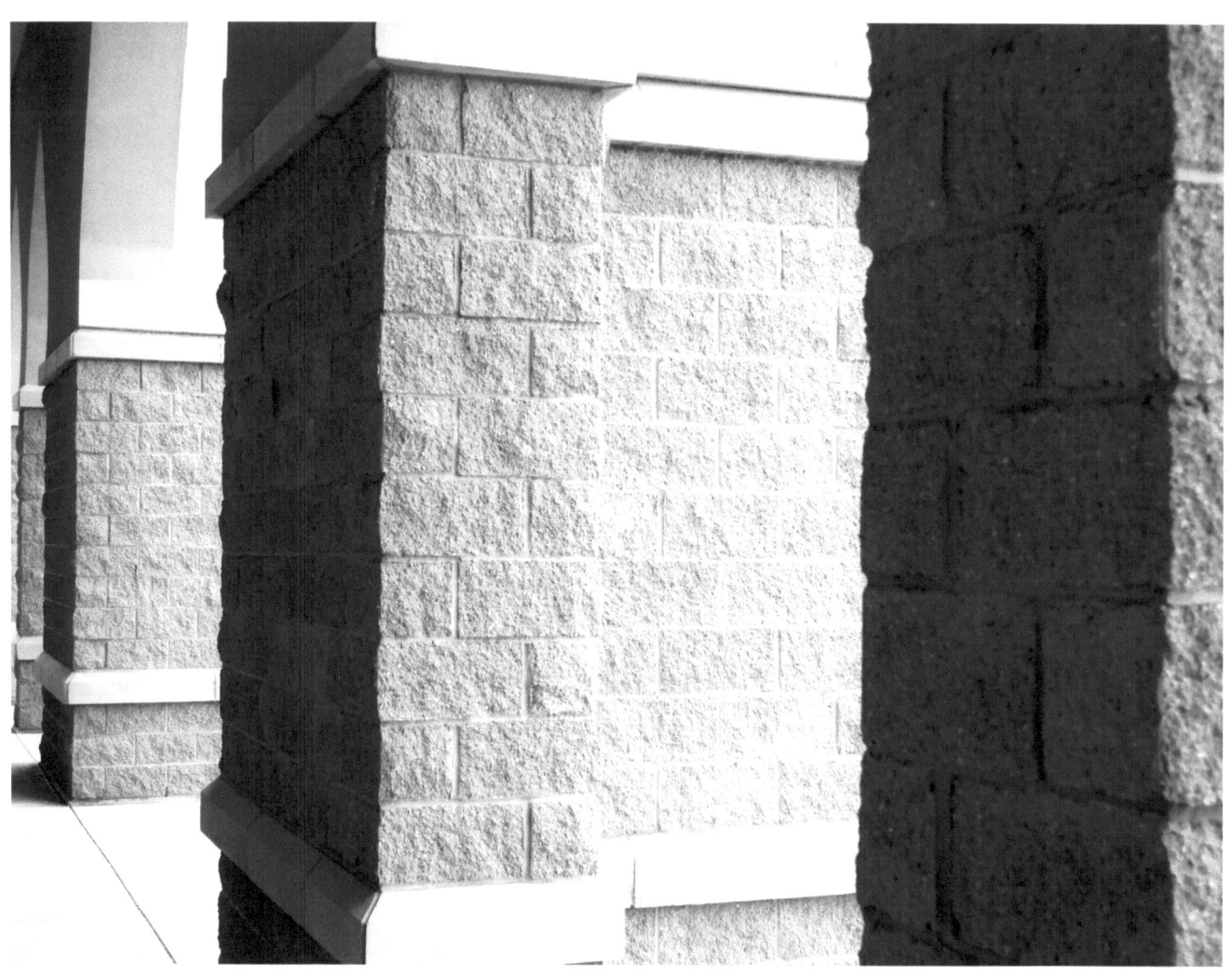

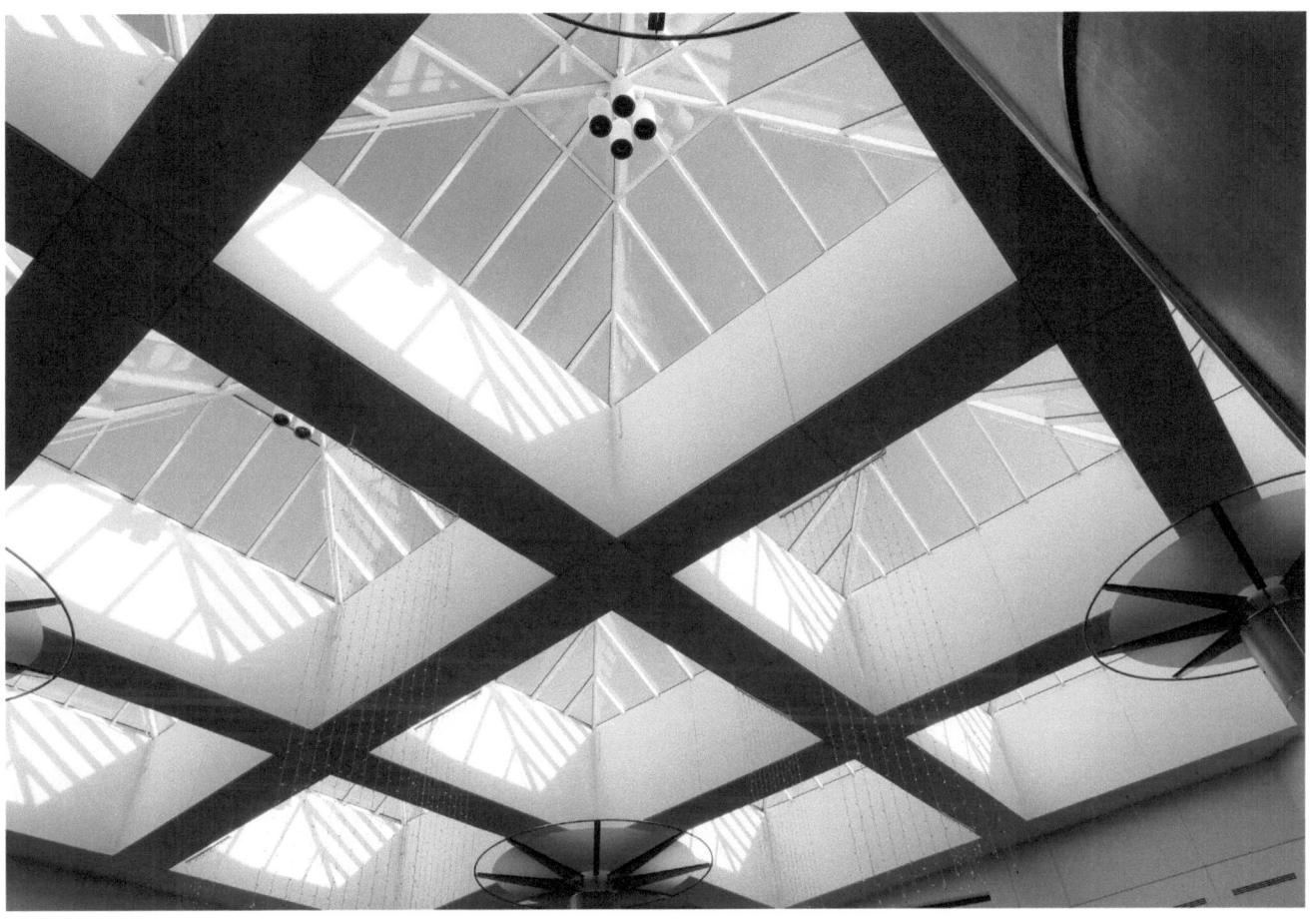

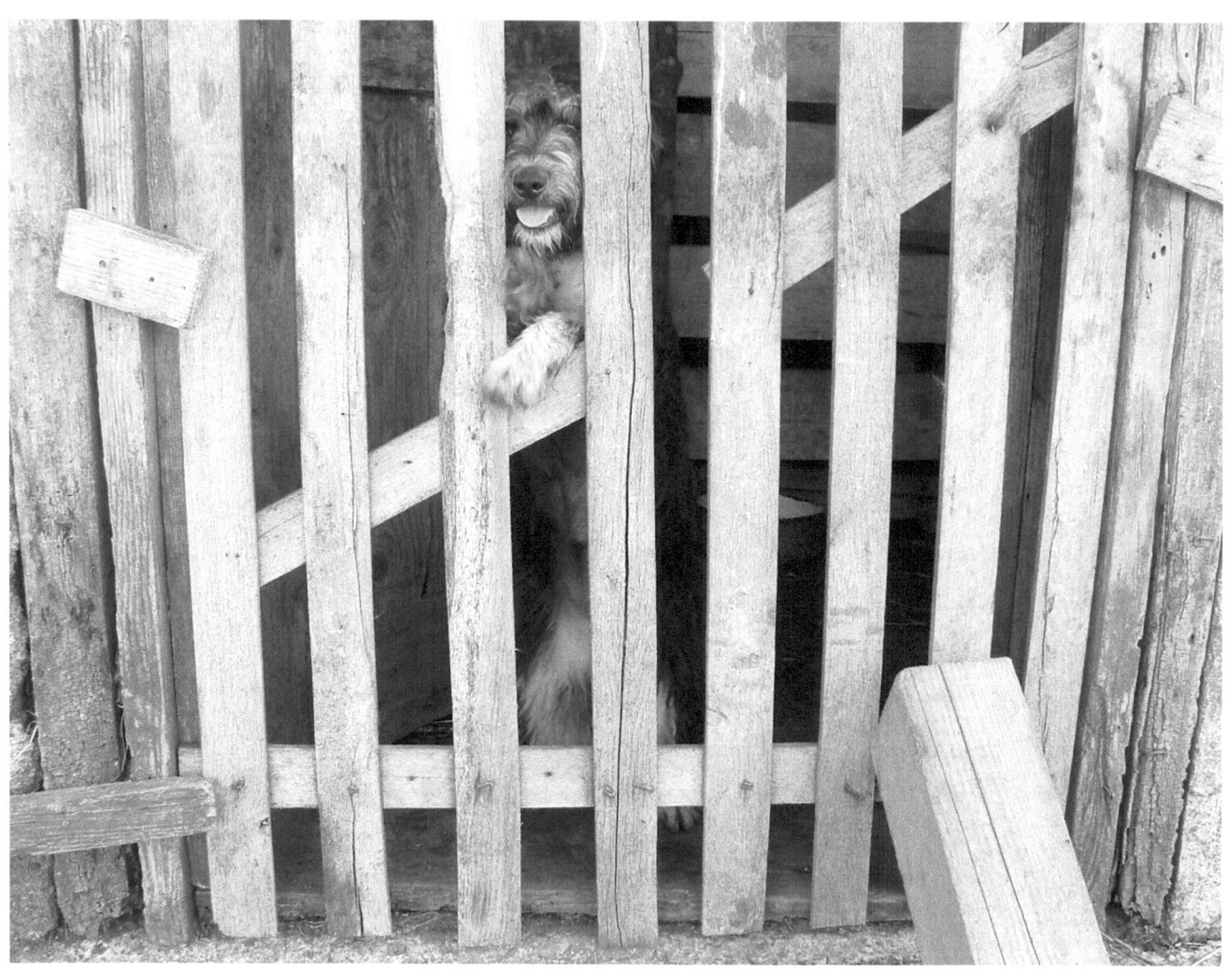

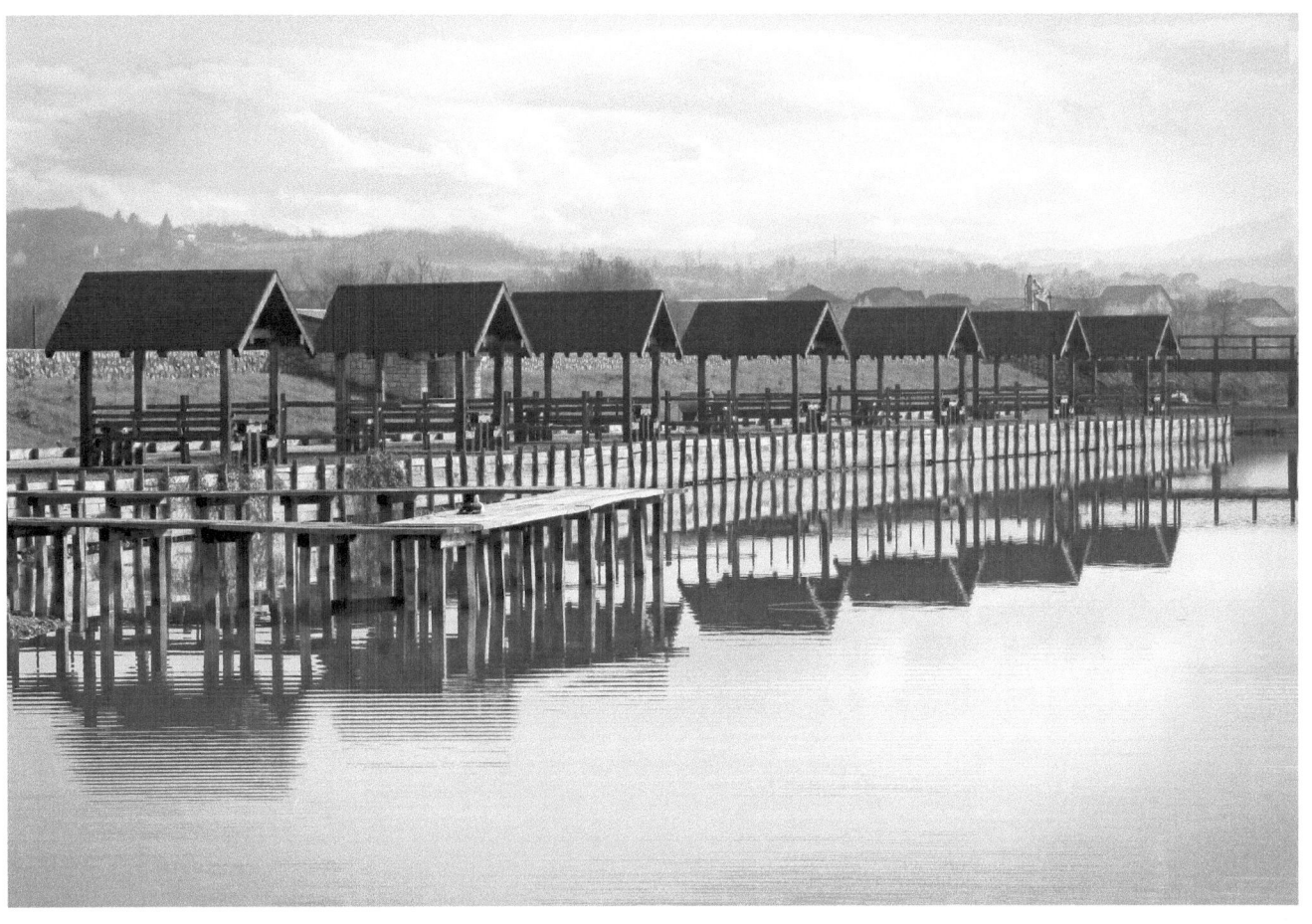

CONNECTIONS

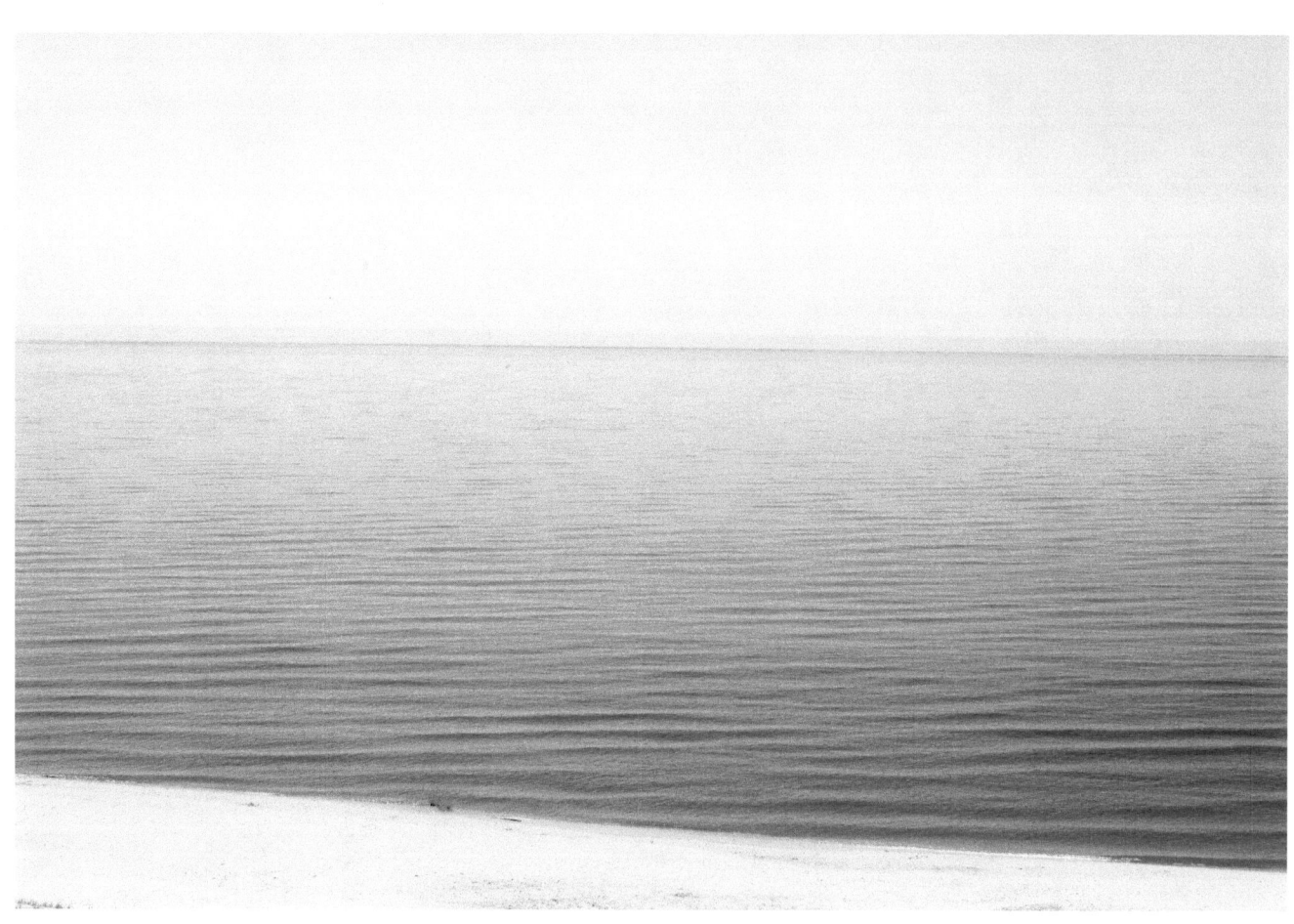

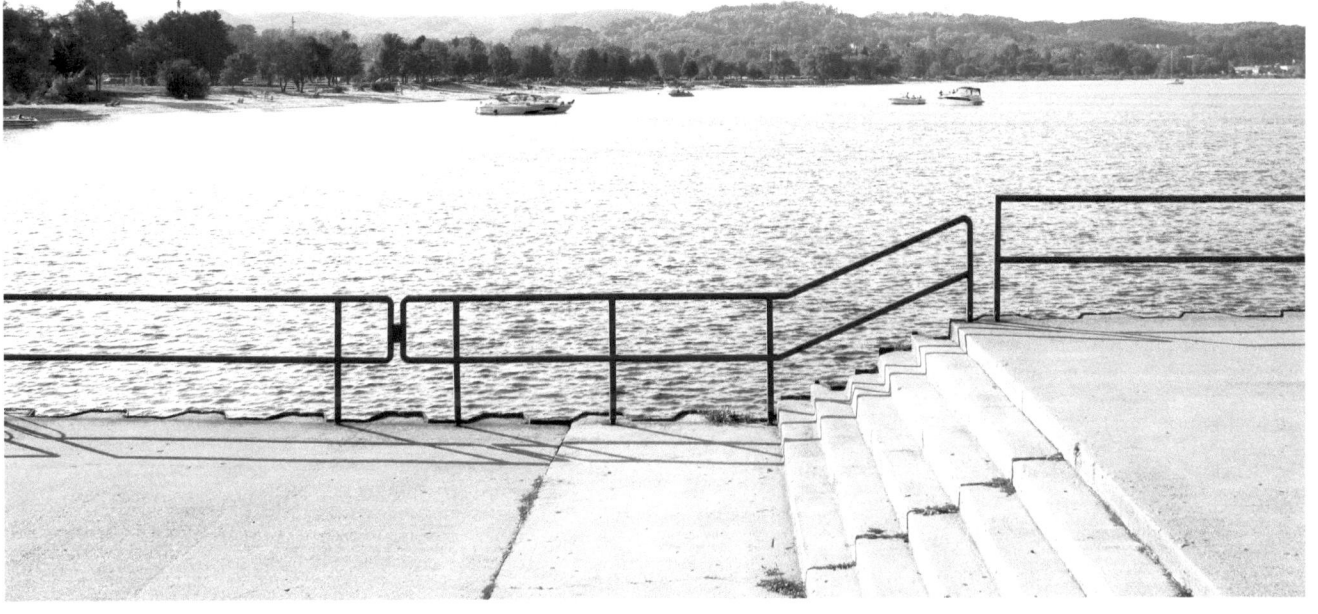

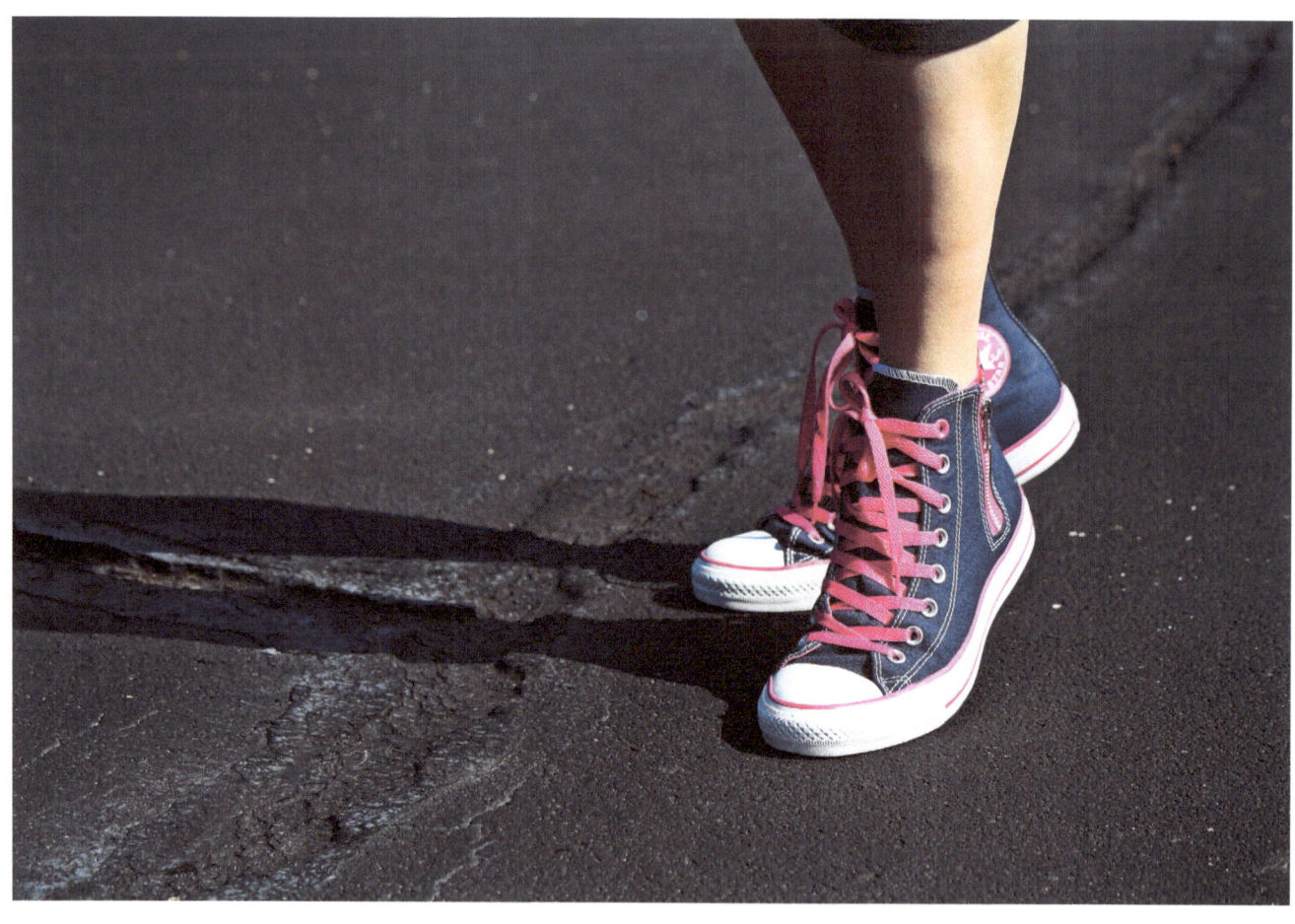

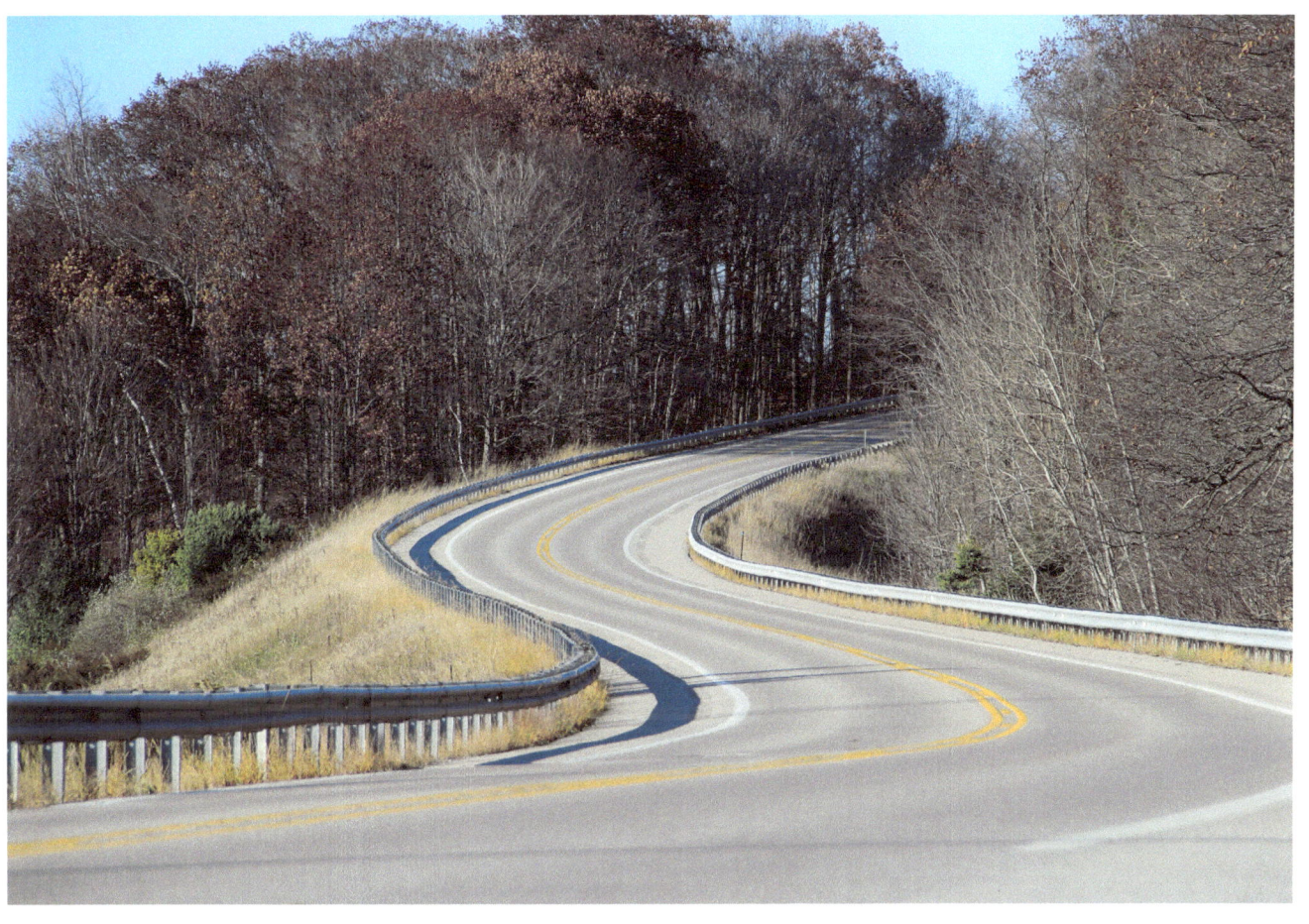

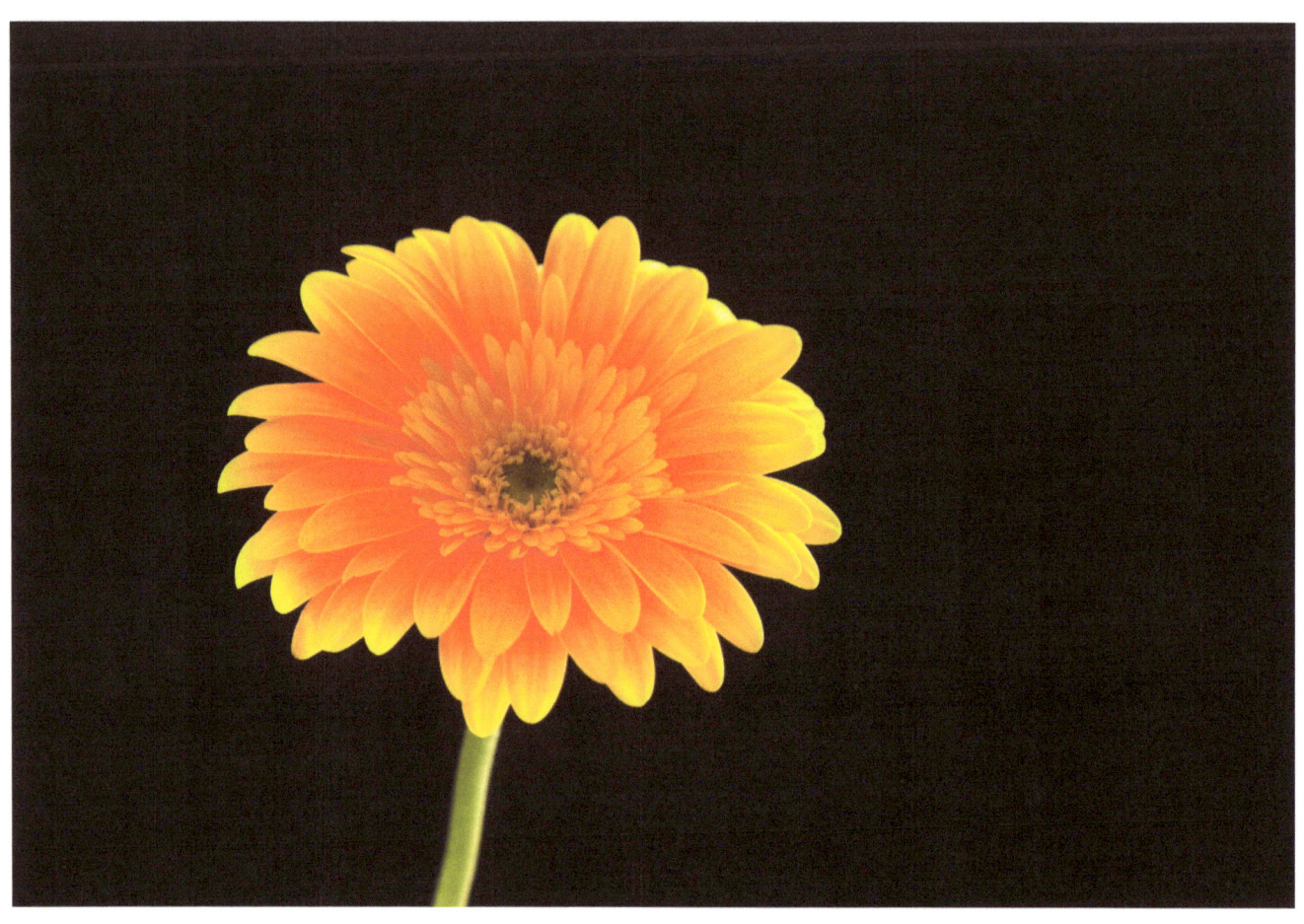

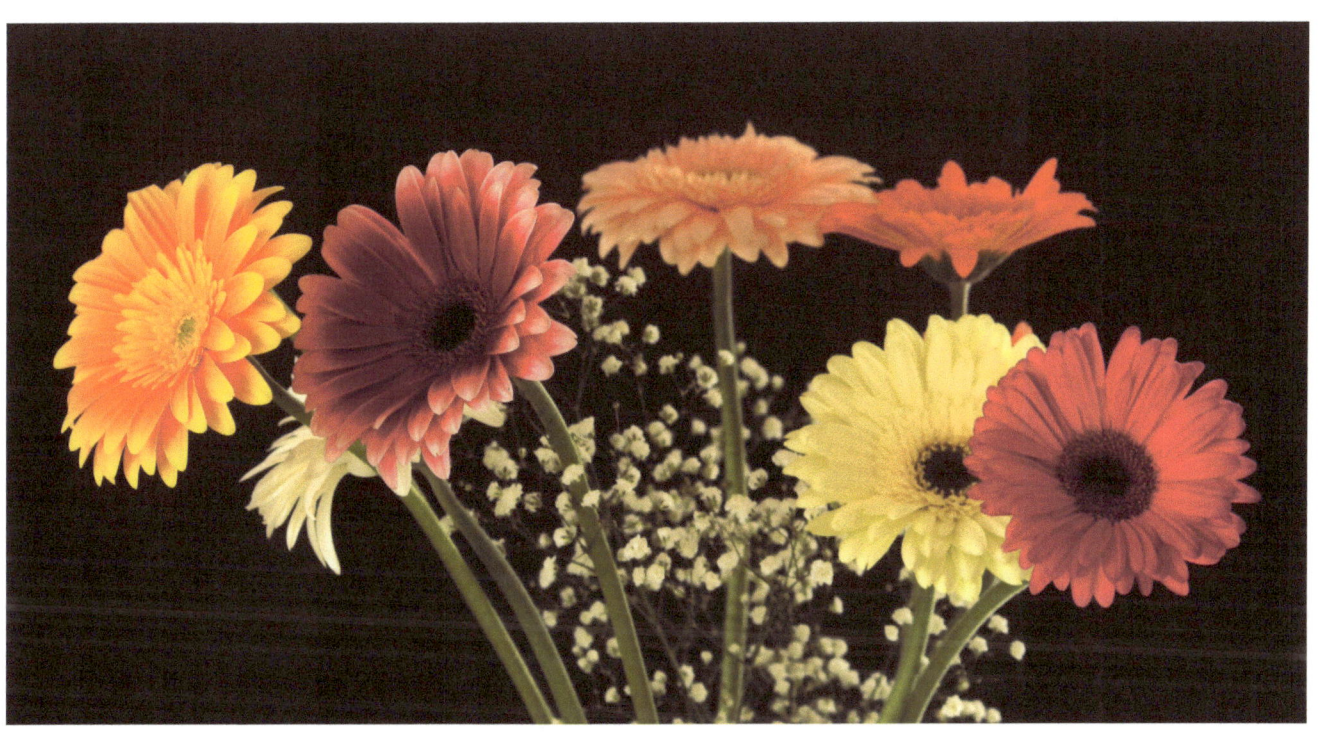

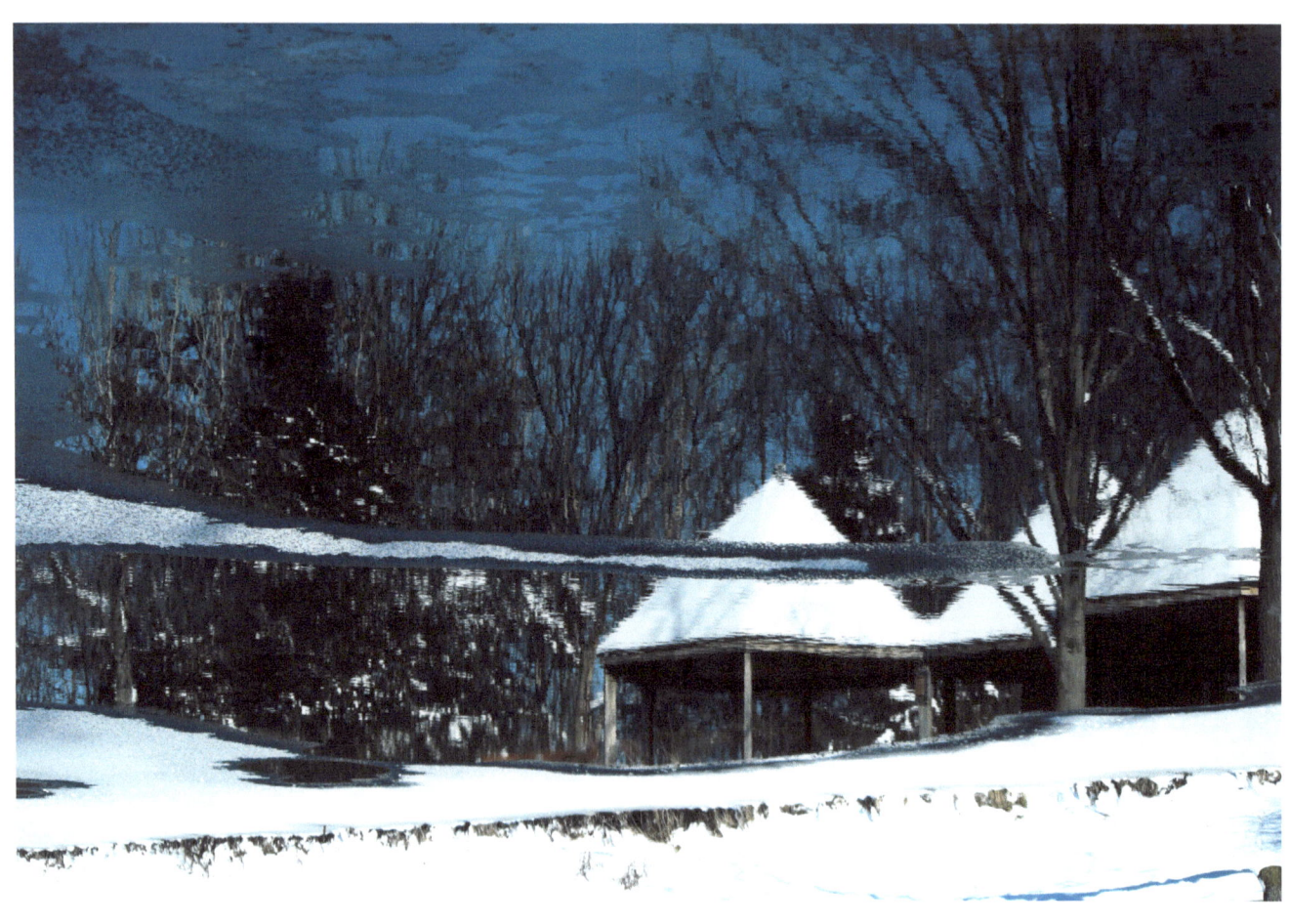

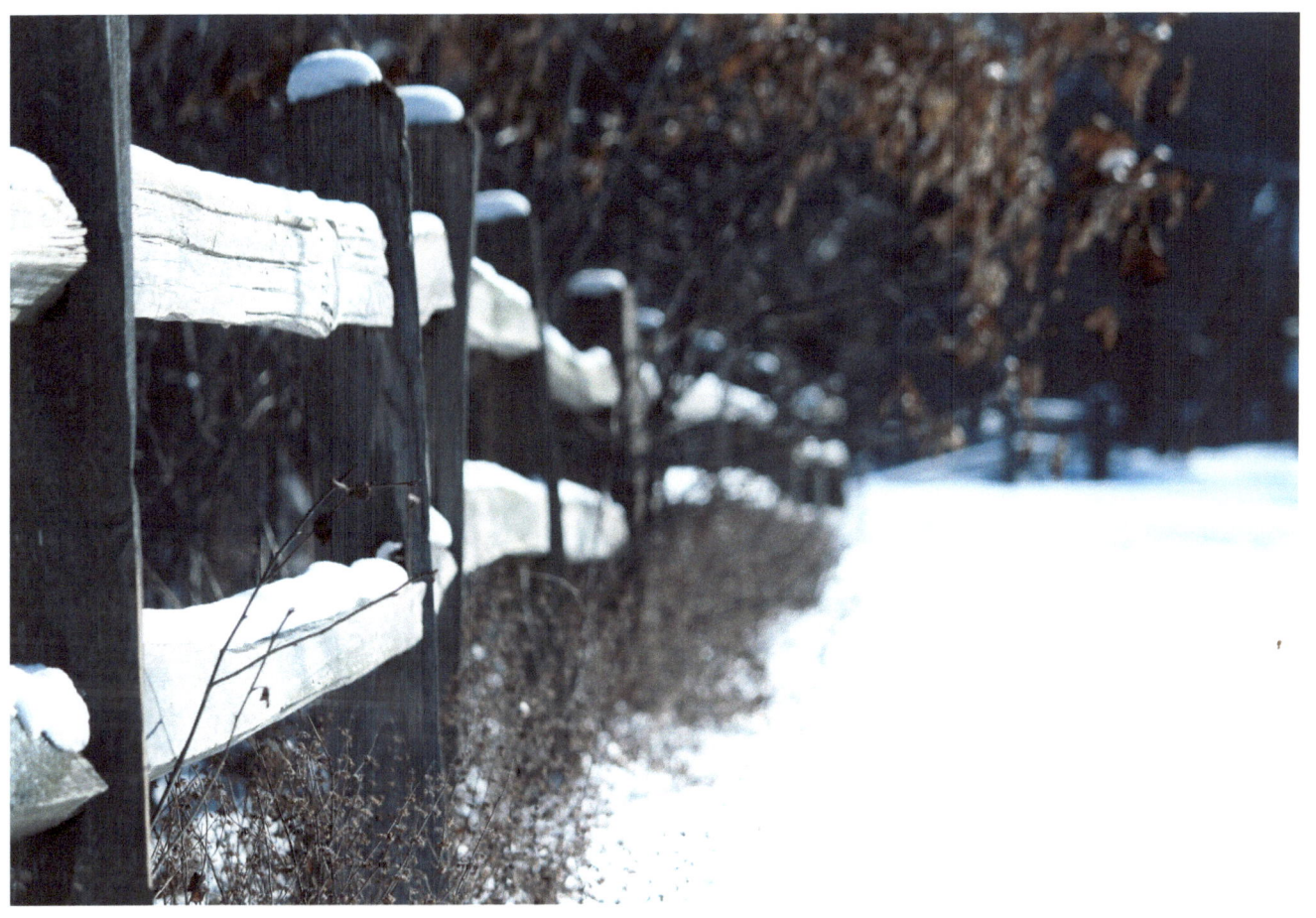

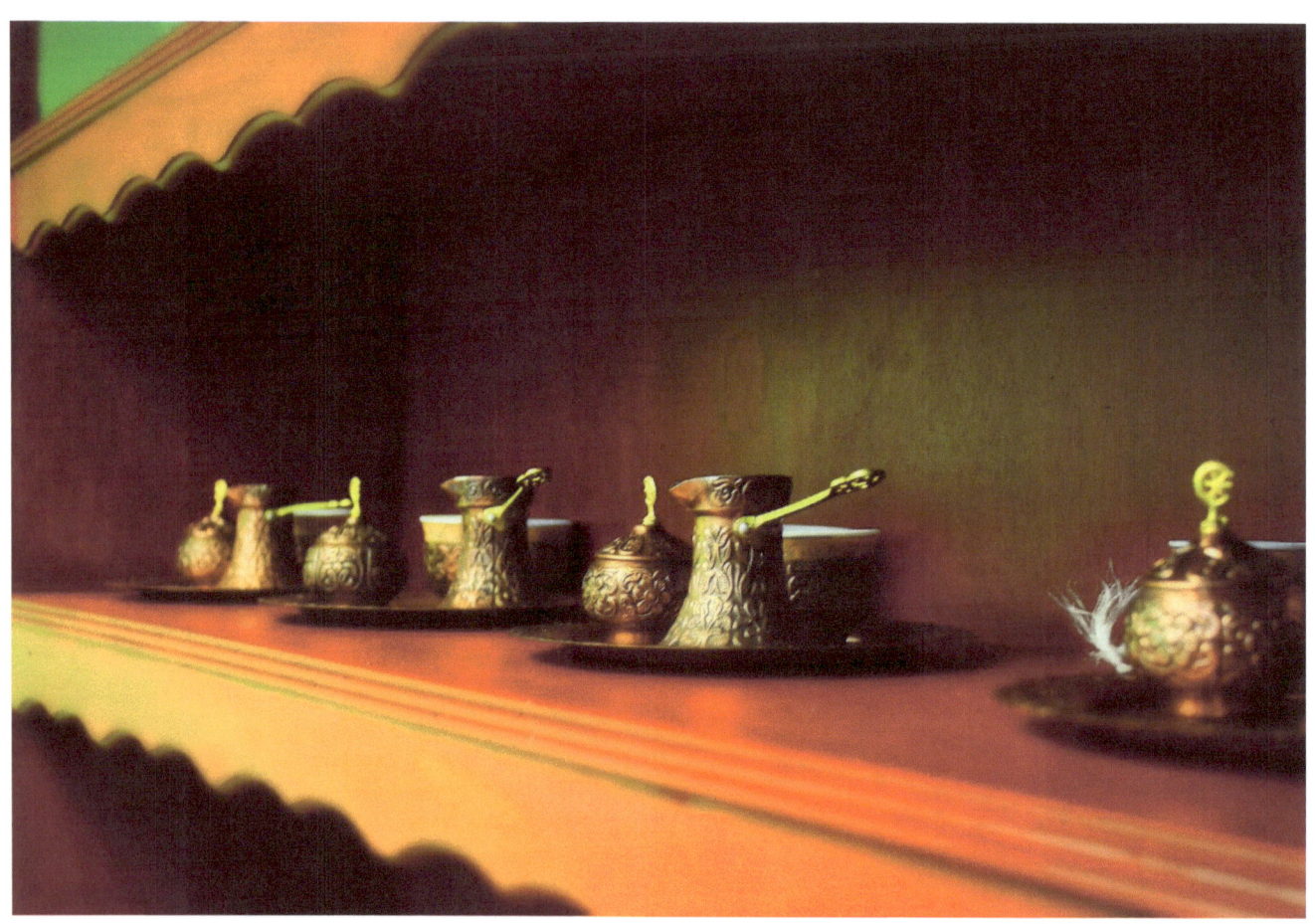

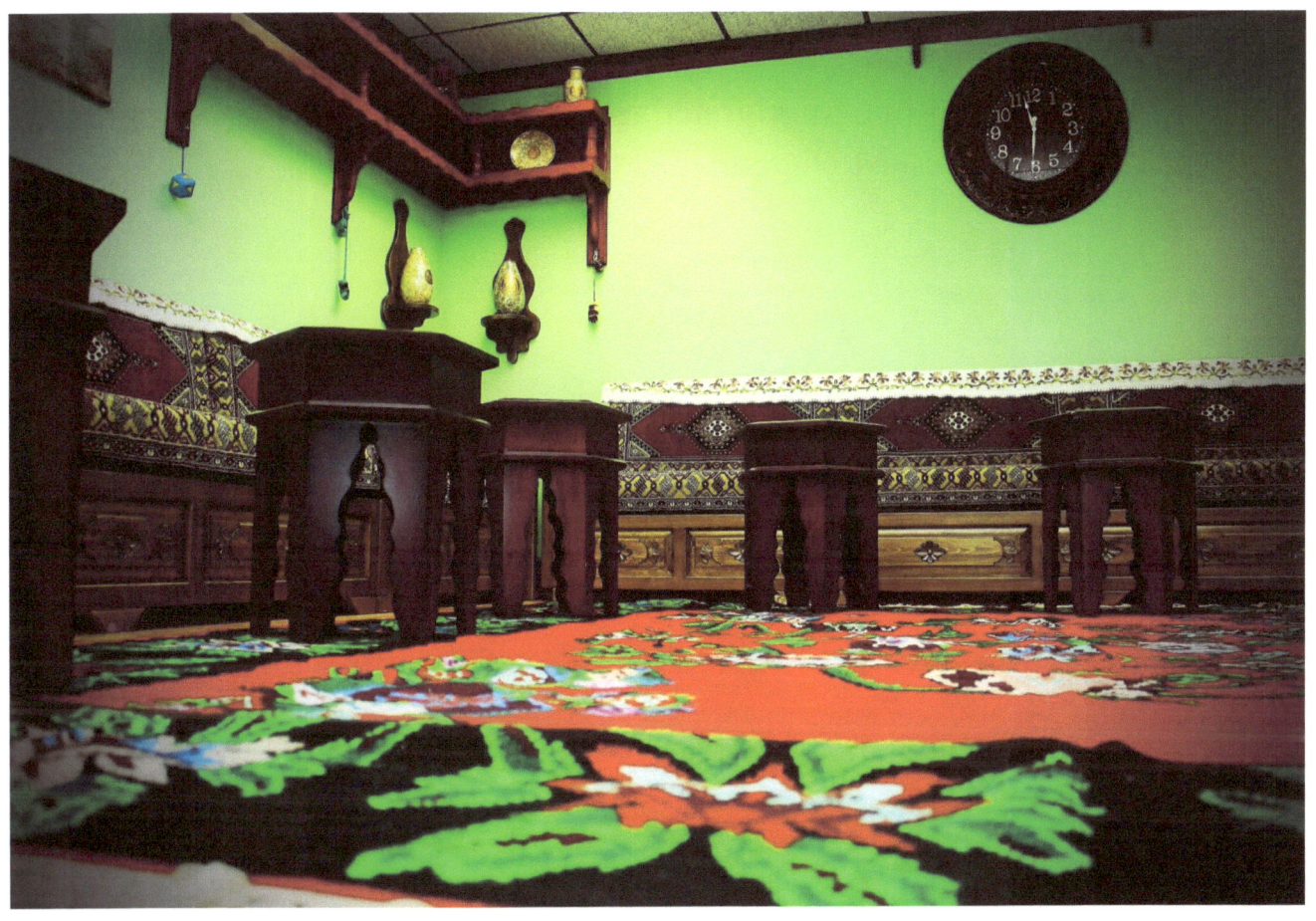

About the author:

Enis Mahmutovic

Born in Bosnia, immigrated to USA in 2001. Hobby photographer. Lives and works in west Michigan...

www.ingramcontent.com/pod-product-compliance
Lightning Source LLC
Chambersburg PA
CBHW050910180526
45159CB00007B/2855